Thank you for taking the
time to look at my book
and there are more books
Helen's Hat Shop
The Hat go to the Derby
The Hat Vacation at the
 Dude Ranch

No part of this book may be
Reproduced stored in a retrieval system
or transmitted by any mean without
the written permission of the author.

Published by Creative Space 6/30/2016
ISBN -13 – 978- 1548348953
ISBN- 10 - 1548348953
library of congress # 2013909690

To my nephew Bentley Bass

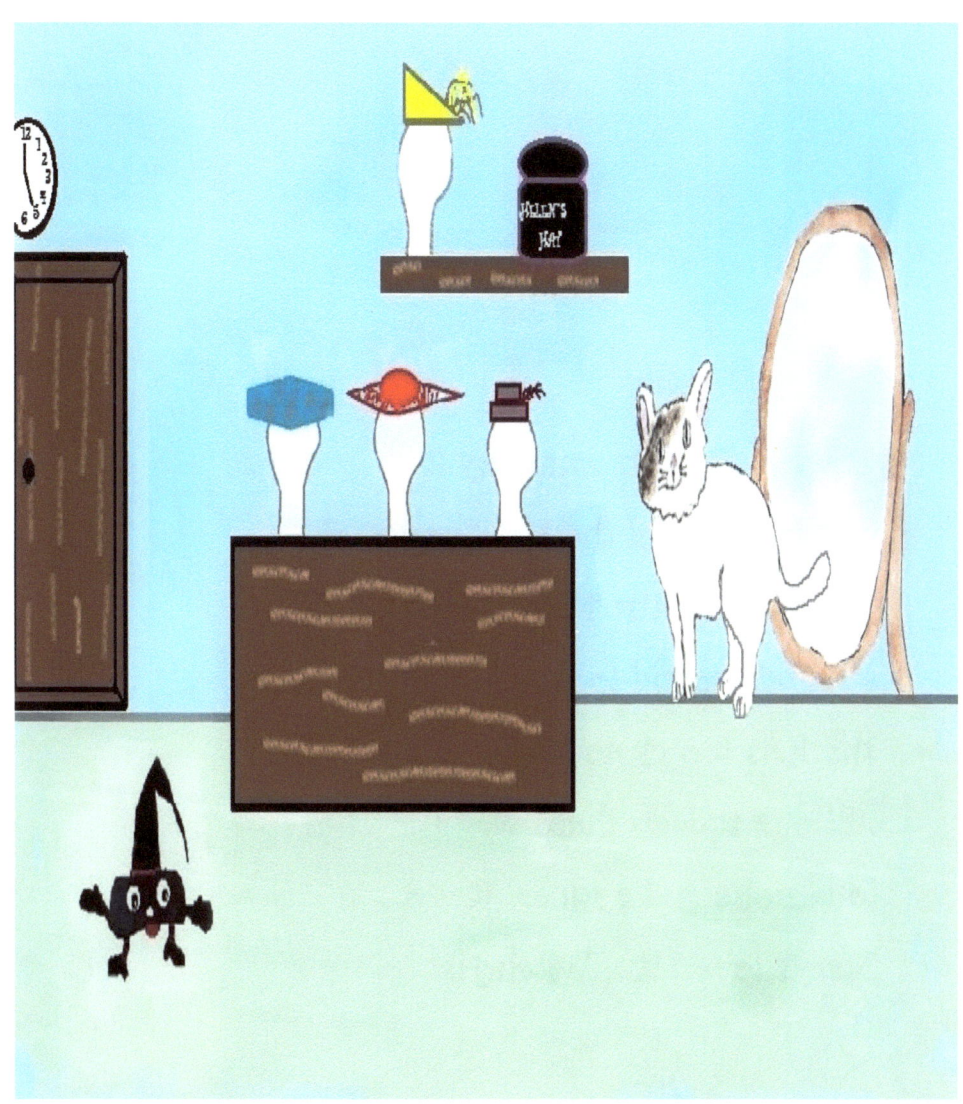

It was a long summer day it was Sunday and the Hat Shop was closed. Miss Mary was walking around looking for the Rats too chase after. All of a sudden there was a loud noise and a squeal it was Mary's love Miss. Witch Hat

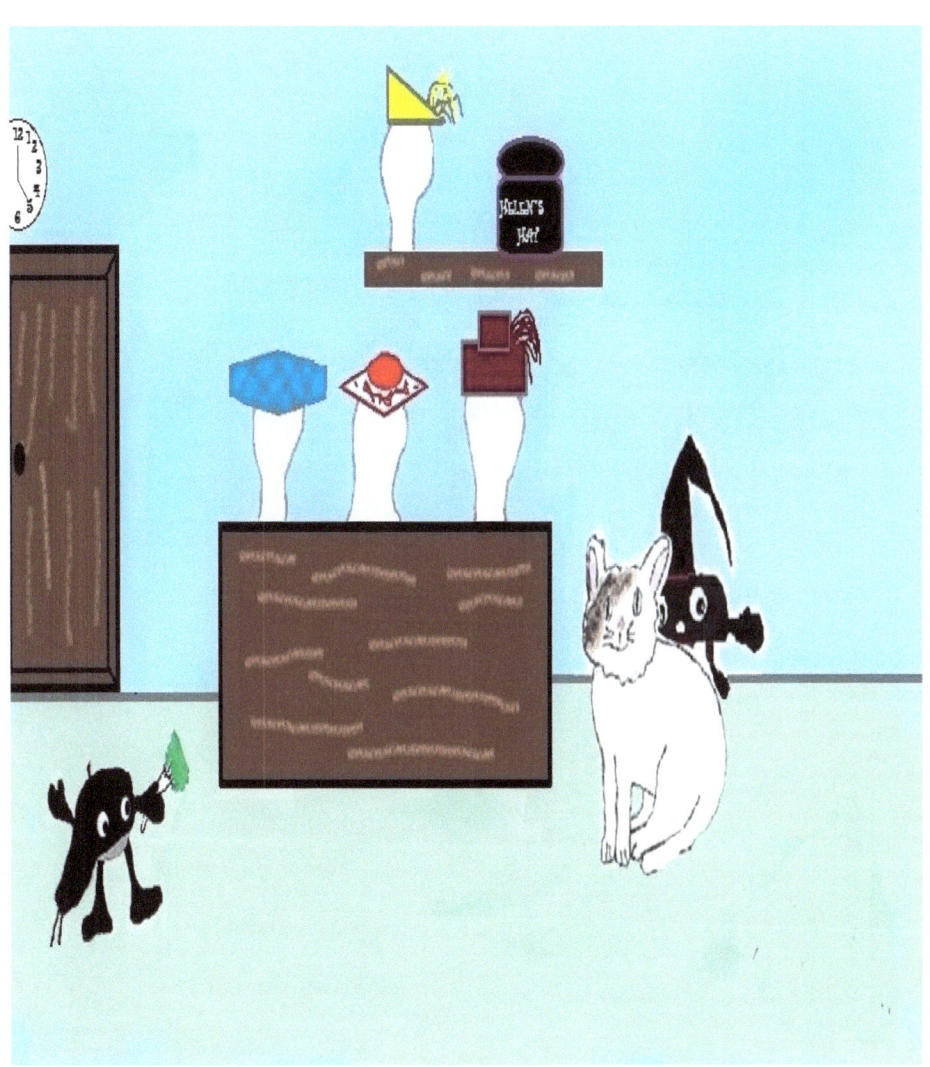

Miss. Witch Hat she was running and crying and got behind Mary and said help me Mary are Mary those Art Hats trying to paint me with those colored paint brushes.

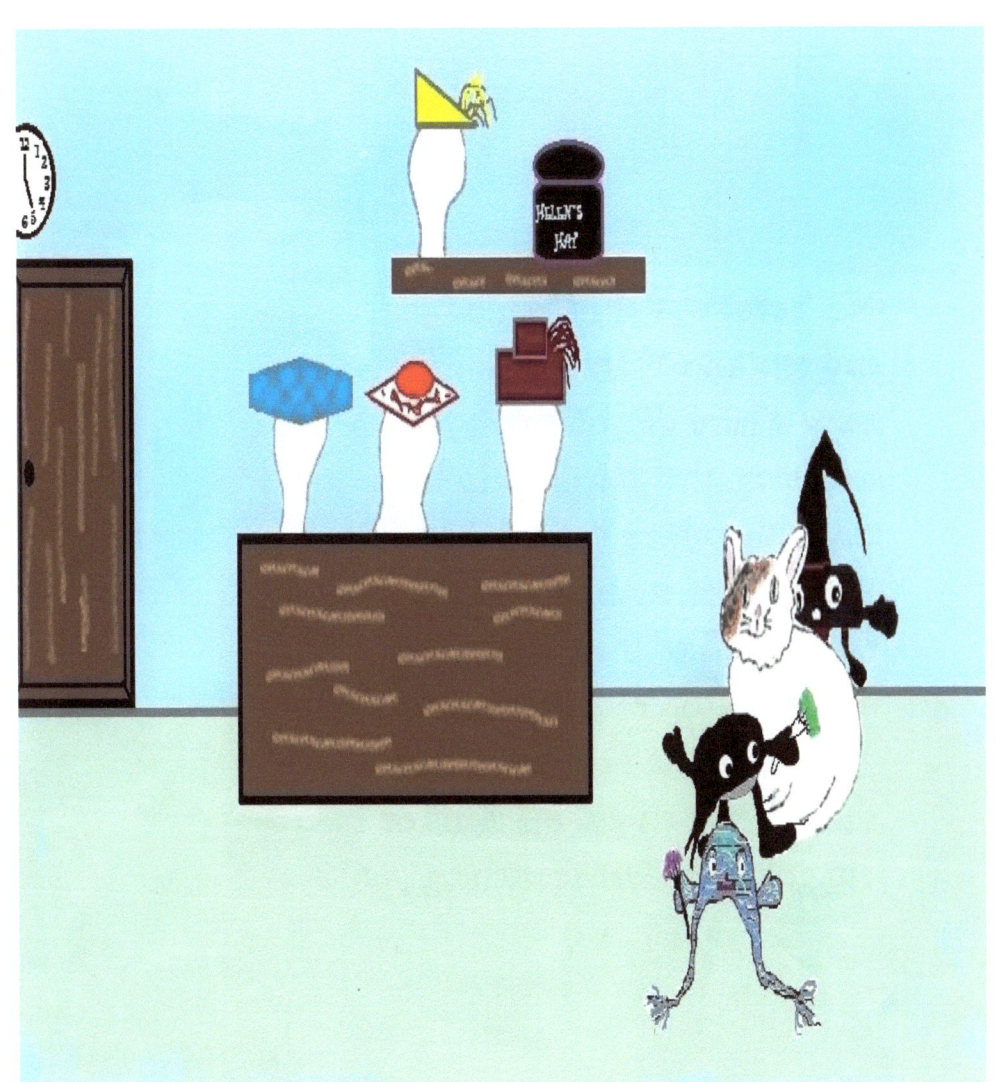

Mr. Beret was right behind
and ran into Mary. Mary
asked where do you think you
are going. that stop him in his
tracks then here came Miss.
Floppy Ears running and she
ran into all of them. They both
where on top of Mary and
she was on the bottom of them
she said you all get off right or I
am going to start scratching you.

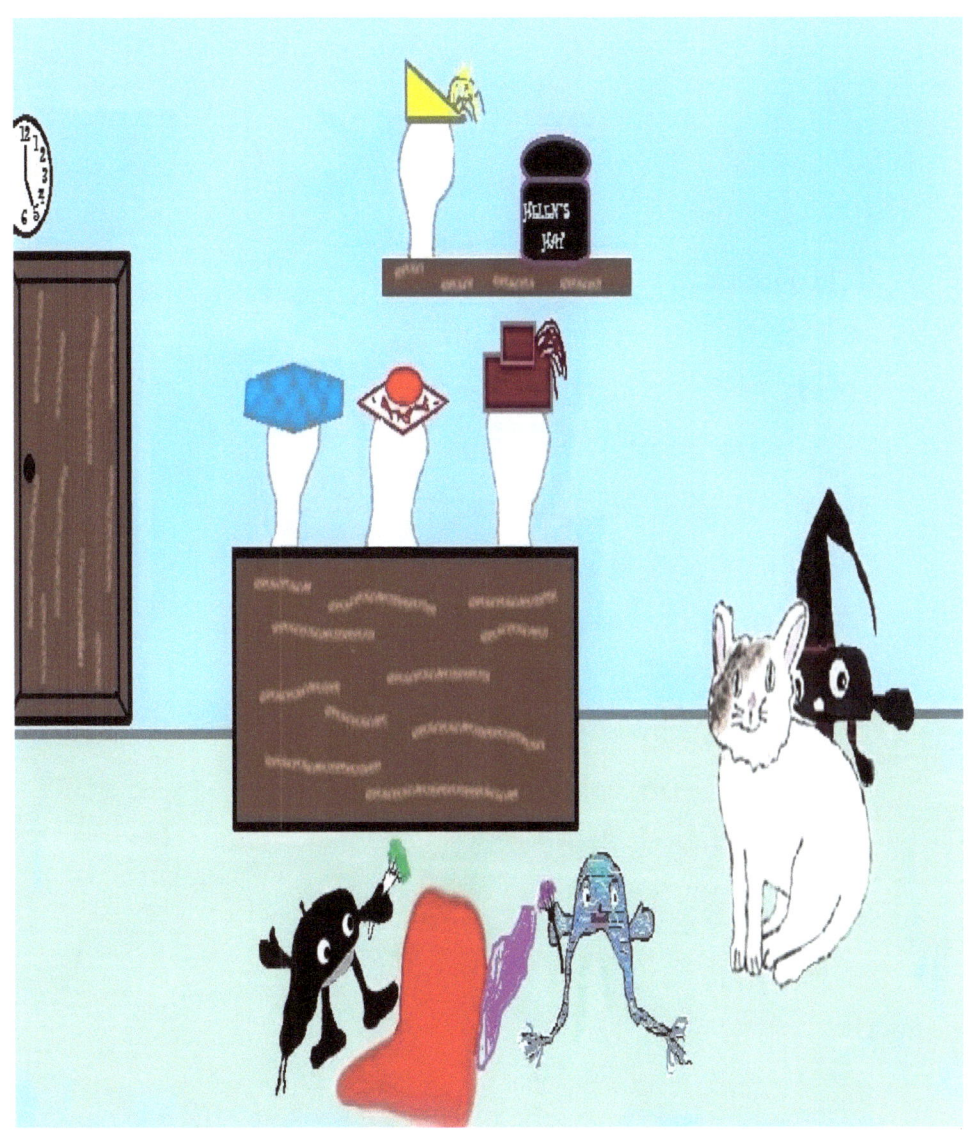

The Hats climbed off real fast
of Mary they were laughing.
Mary said it not funny you
guy leave Miss Witch Hat
alone she like being black
Mr. Beret Hat said she would
look so much better in color,
Miss. Floppy Ears said that
right dear maybe a pretty
purple No, no, said Mr. Beret
she would look good as a
 RED HAT

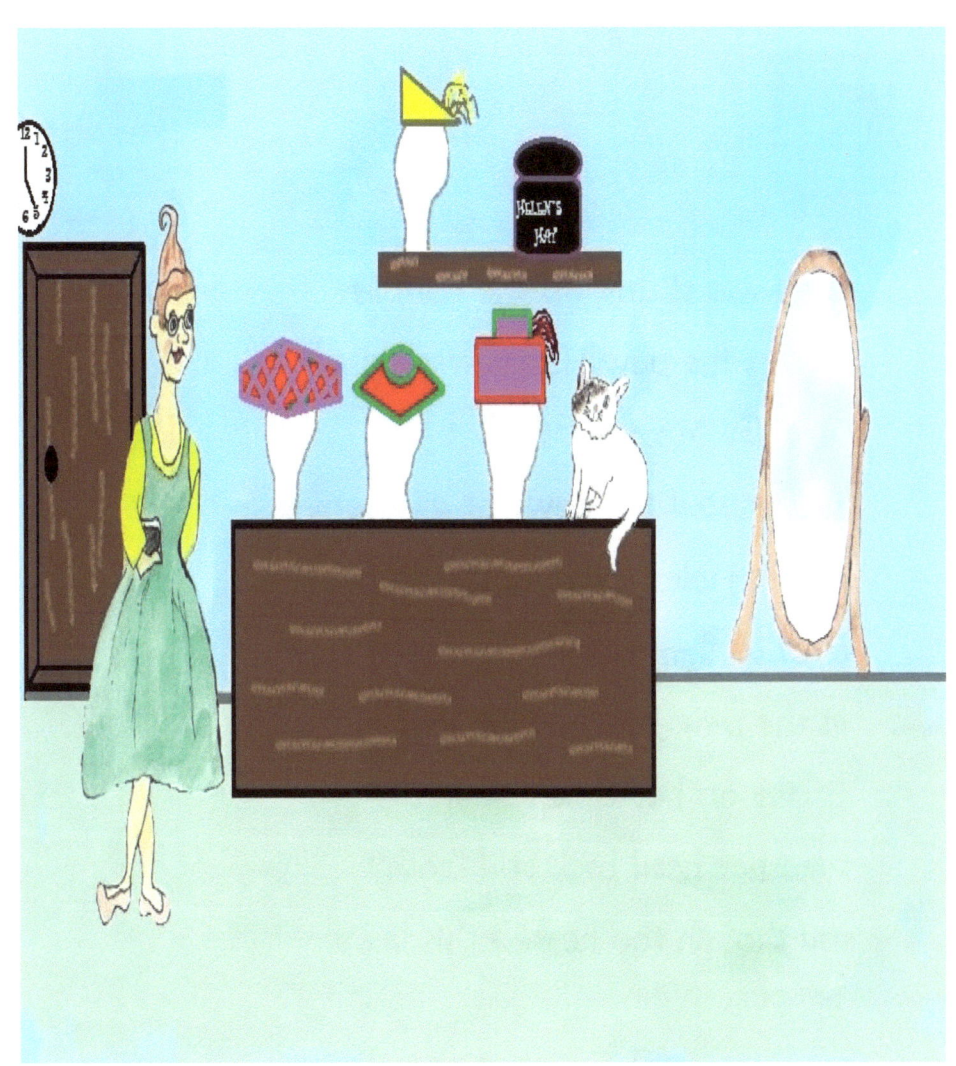

Mary was sitting on the counter
look at the new Hat. It was
Monday Morning the art Hat
had painted the new hat different
colors Helen came in she went
over to the counter to look
at the new Hat. She had put her
finger on her chin and was
turn her head back and frothy
and though too herself this keep
happen,

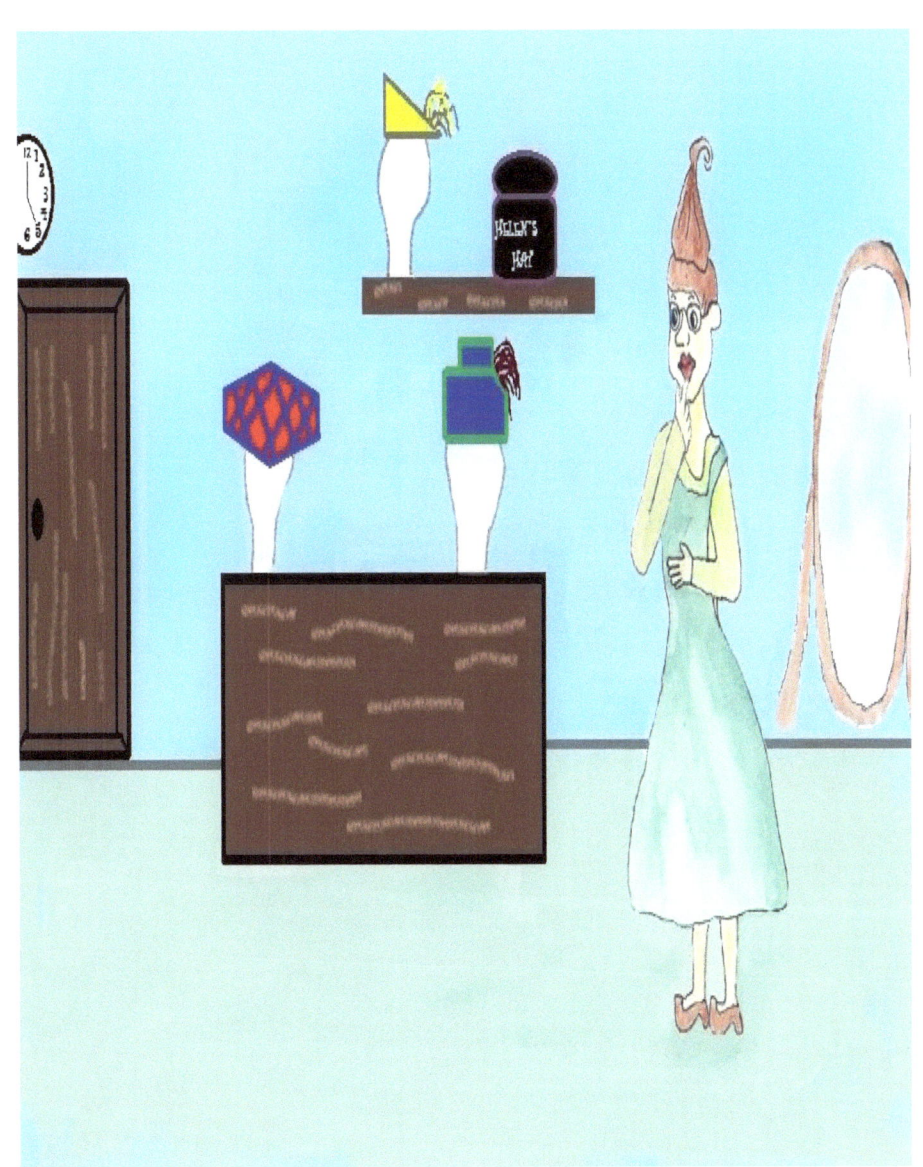

Helen could not figure out
how the Hats keep on changing?
colors. there four she had to start
all over again with the new Hat's
for Mrs. Hubbard daughter It was
a good order a very special order.

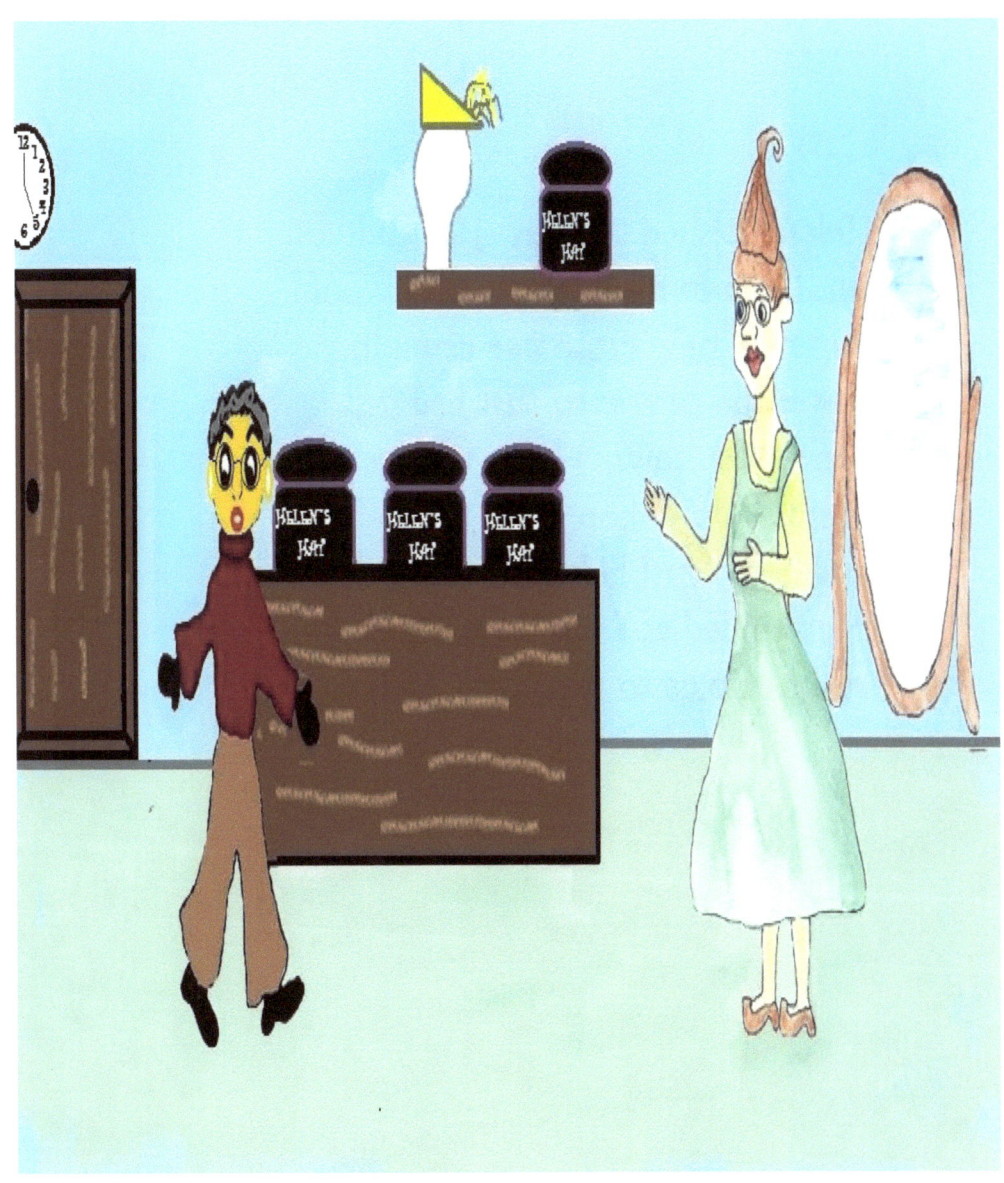

Helen finished the new Hat and
put them in a hatbox so they would
be safe a new customer came in
it was the new man that had just
move into town. Helen said wel-
-come to my shop. I am Helen
and how can I help you today. The
Man smiled and said I am Jim
and it is nice to meet you. Helen.

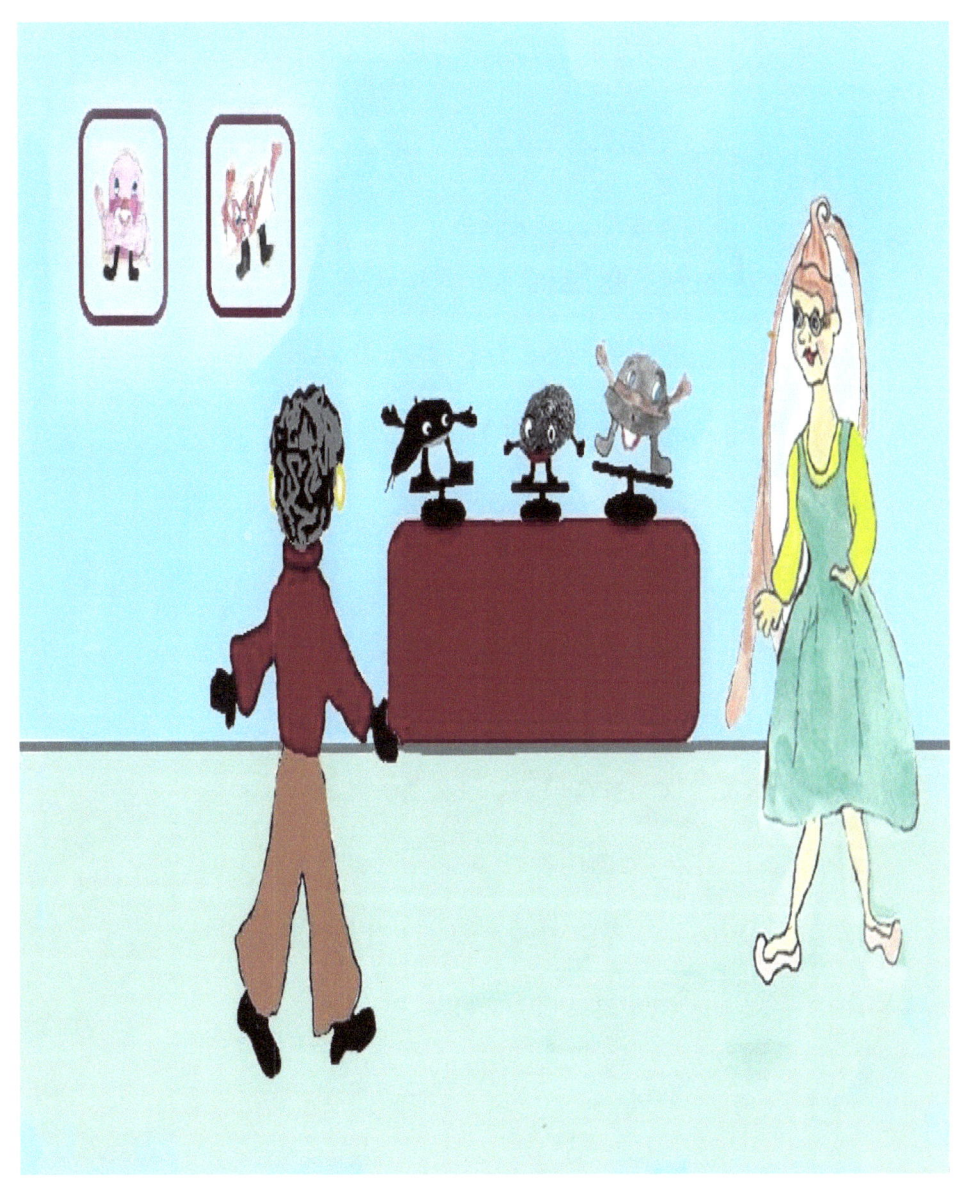

Jim said Mrs. Hubert said to stop
by and meet you, and tell you the
kind of Hat I am looking for,
Well that was so nice of Mrs.
Hubbard Helen said looking at Jim
and took him to the men section
where the man's Hats were Jim
picks out Mr. Iron Hat but he asked
Helen if she could put a different
color brim on the hat Helen showed
Jim the different brims and he pick
out a Maroon for Mr. Iron Hat

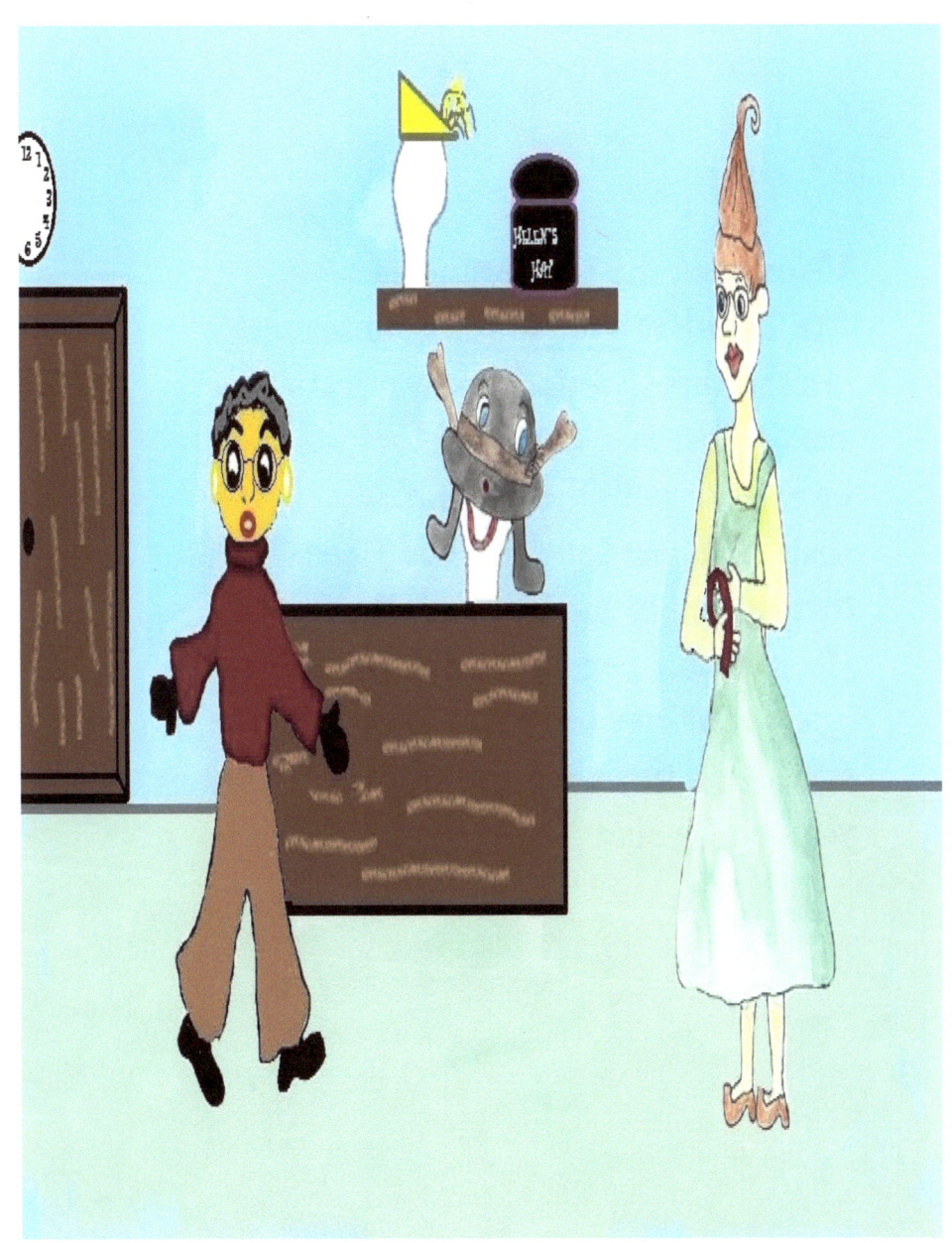

Helen took the new brim and
Mr. Iron Hat over to the counter.
As she turns around Jim was just
next to her and they both look at
each other with their face close
their nose was touching and Helen
turn all red in the face and Jim smiled
Helen would you be kind to be me
guest at dinner tonight? Helen
smiled and turns red and said why
yes, Jim I would

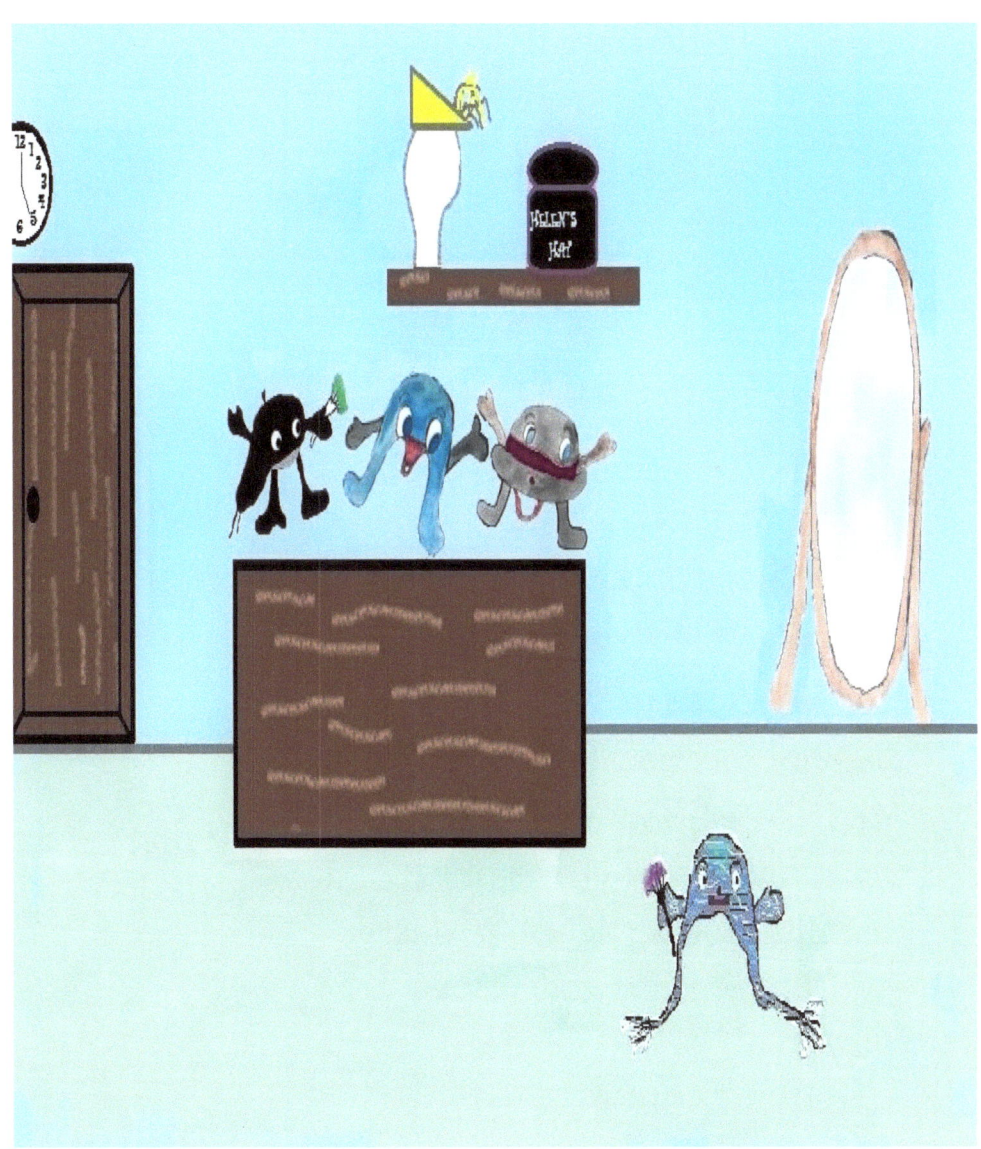

Helen Closed up the shop
Miss, Cloche said did you hear that

Mr. Top Hat.? Mr. Beret said let
me paint that new brim for
Mr. Iron Hat. and Miss Floppy Ears
said oh me too I'd like to paint
too Miss Cloche said you two leave
Mr. Iron hat alone and his new brim
I like it.

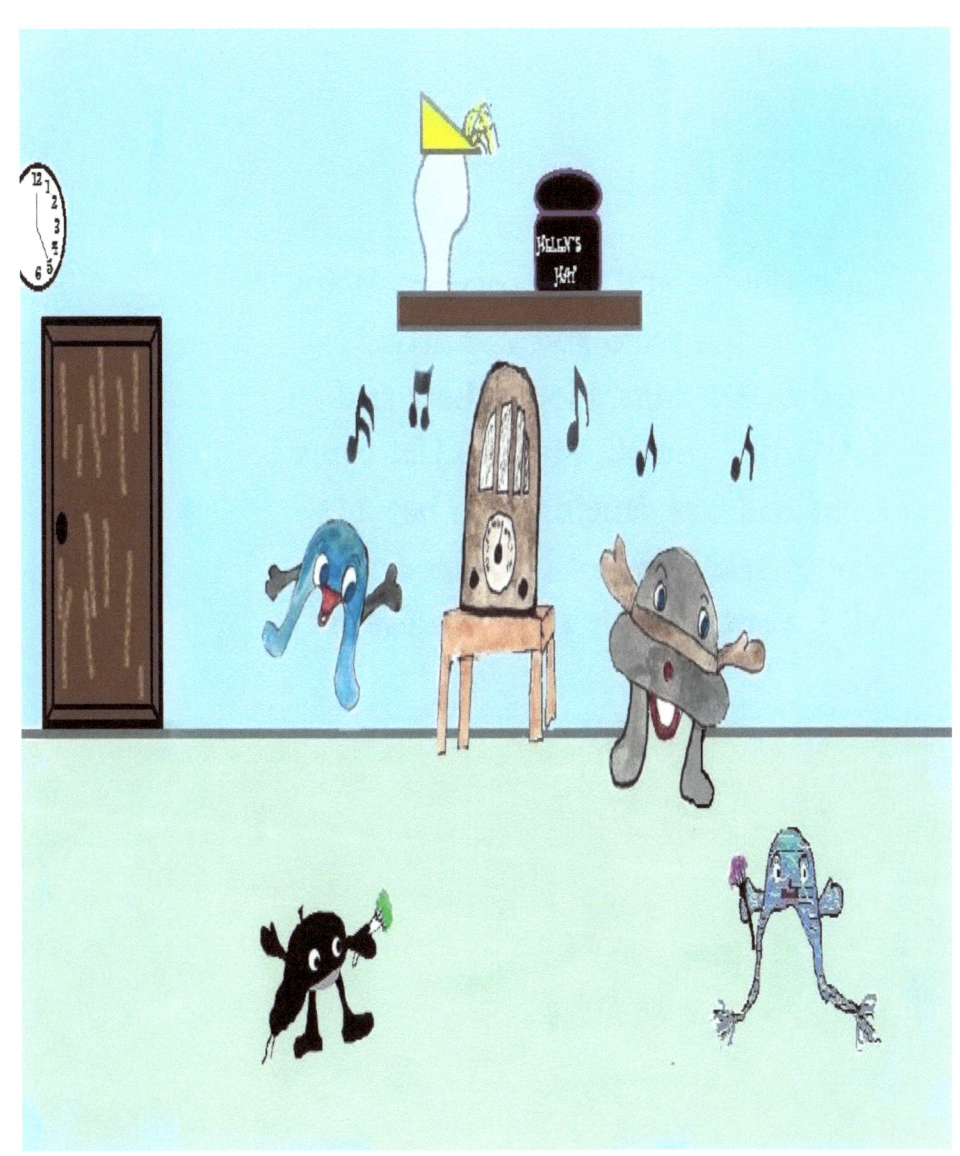

Miss Cloche and Mr. Iron Hat Went
over to the radio and was listing
to the Jazz Miss. Floppy Ears said
let Dance you all. Mr. Top Hat came
over and was dancing with her Mr.-
-Beret said I do not I like to dance
all I wont to do is art, I live for art.

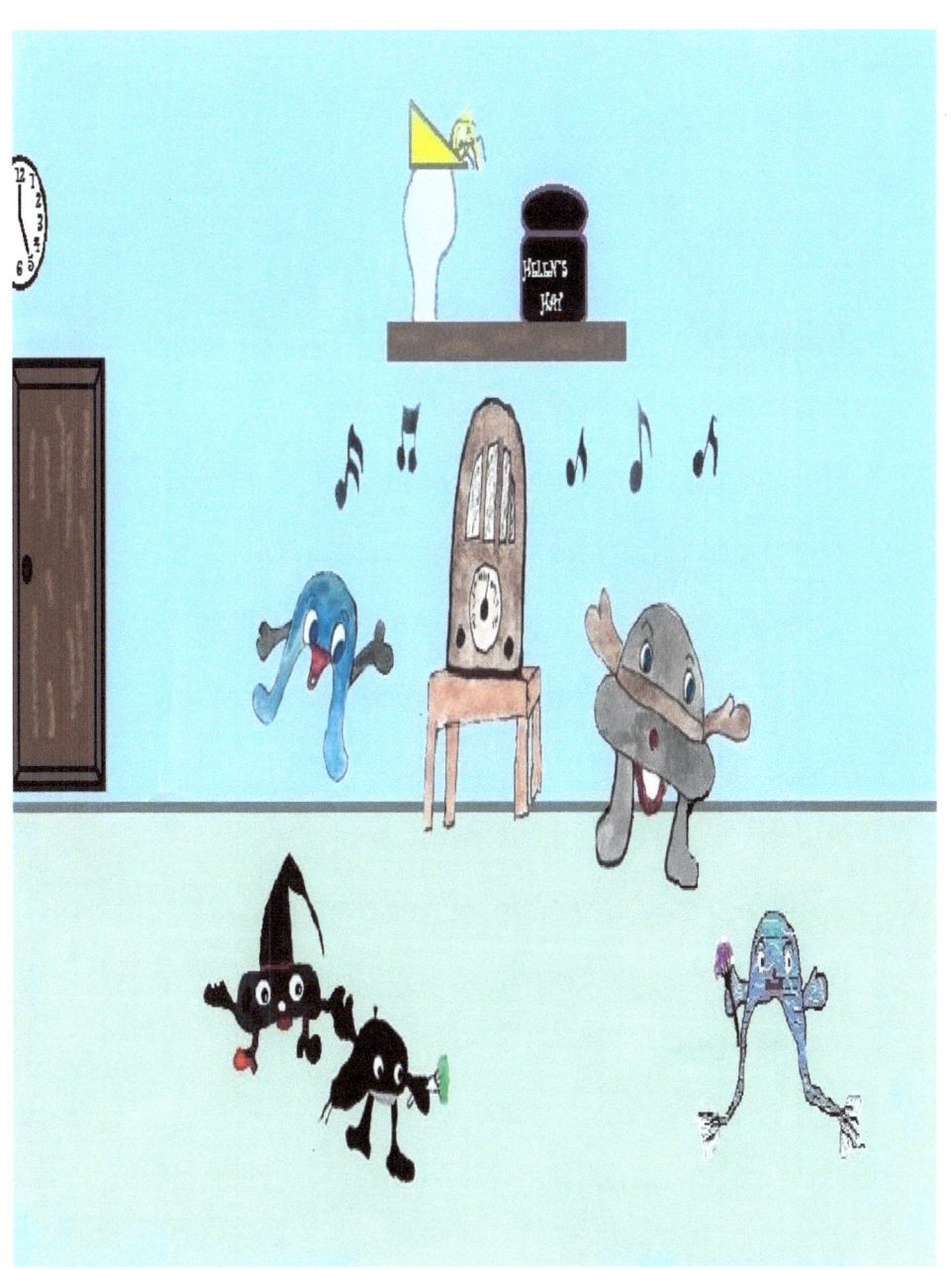

Miss Witch Hat came over and asked
if he would like to try and dances?
He said OK but your problem well be
sorry. Just then he took her hand and
grabs it really tight and them Miss Witch
Hat knows. Mr. Beret smiled and was
laughing and said I've got you Misses
and all of a sudden his paint brush
appeared and dripping of yellow paint.
It could change colors at any time
on its own.

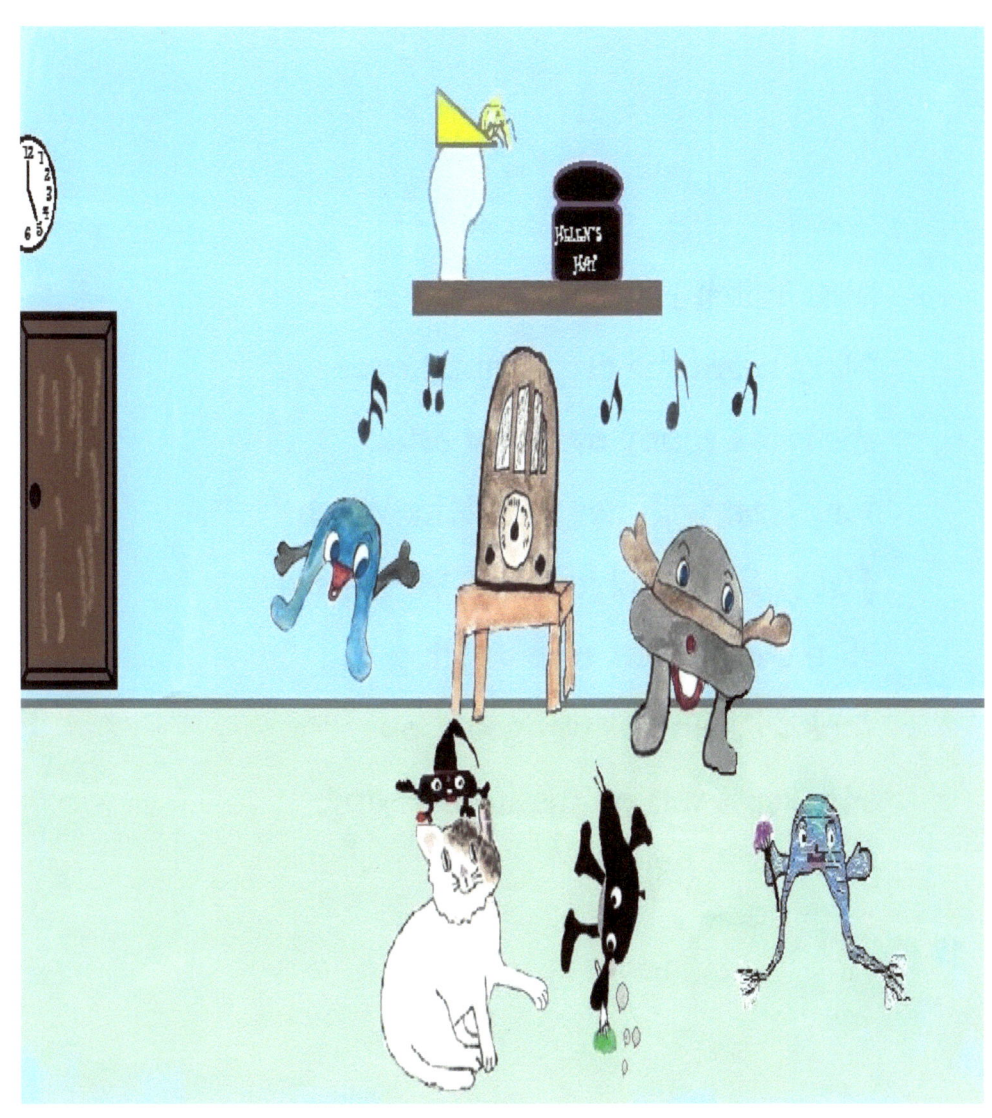

Miss Witch Hat stated to cry and
Mary heard she came runny over
she came runny over and bated
Mr. Beret with her Paw Miss Witch
Hat got loss and jump on Mary head
all the other Hat stop dancing and
look to see what was going on
Mr. Beret was on the floor crying.

(13)

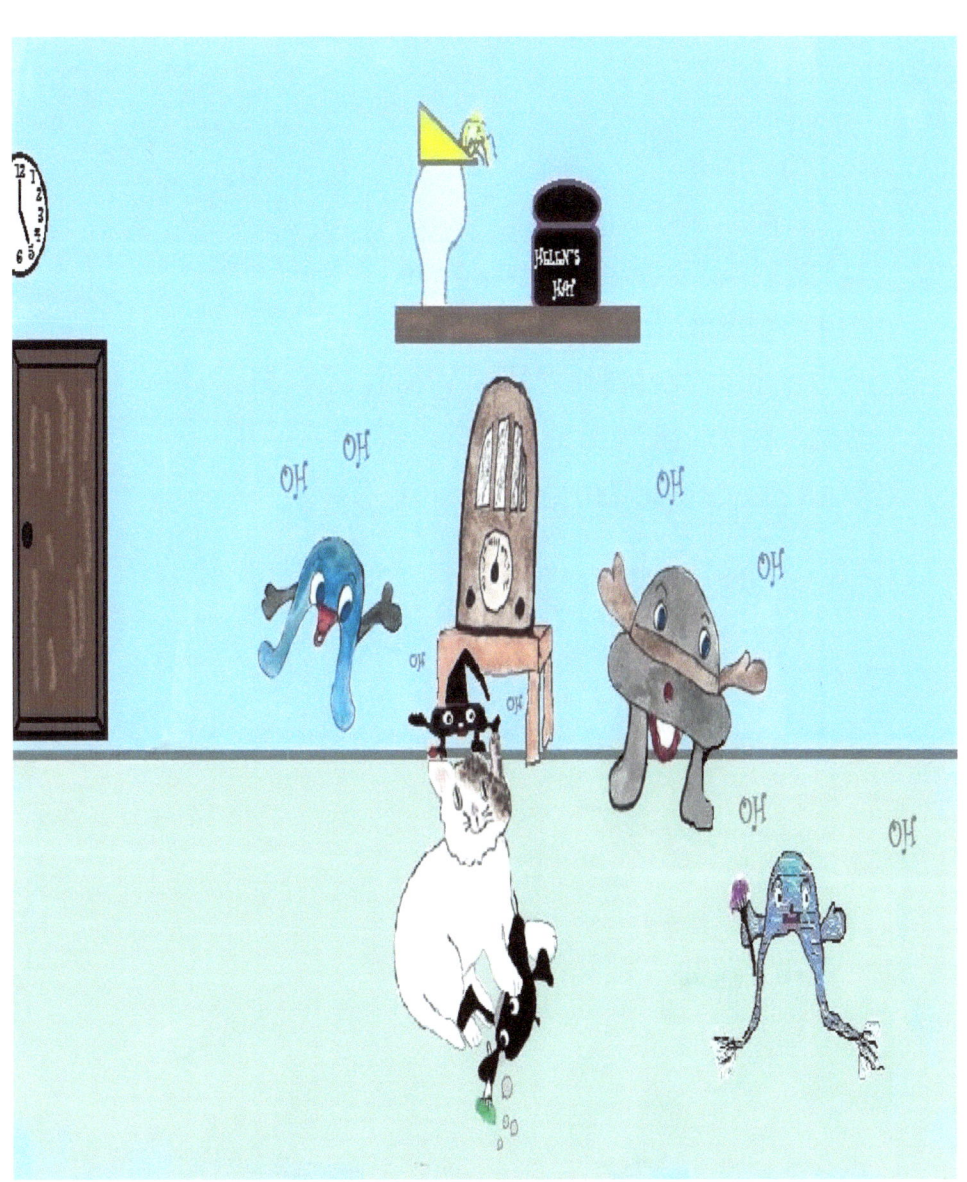

Mary was on top of Mr. Beret and looking down at him. She was telling him to leave Miss. Witch Hat alone from now on. All the other Hats started to laugh at them.

(14)

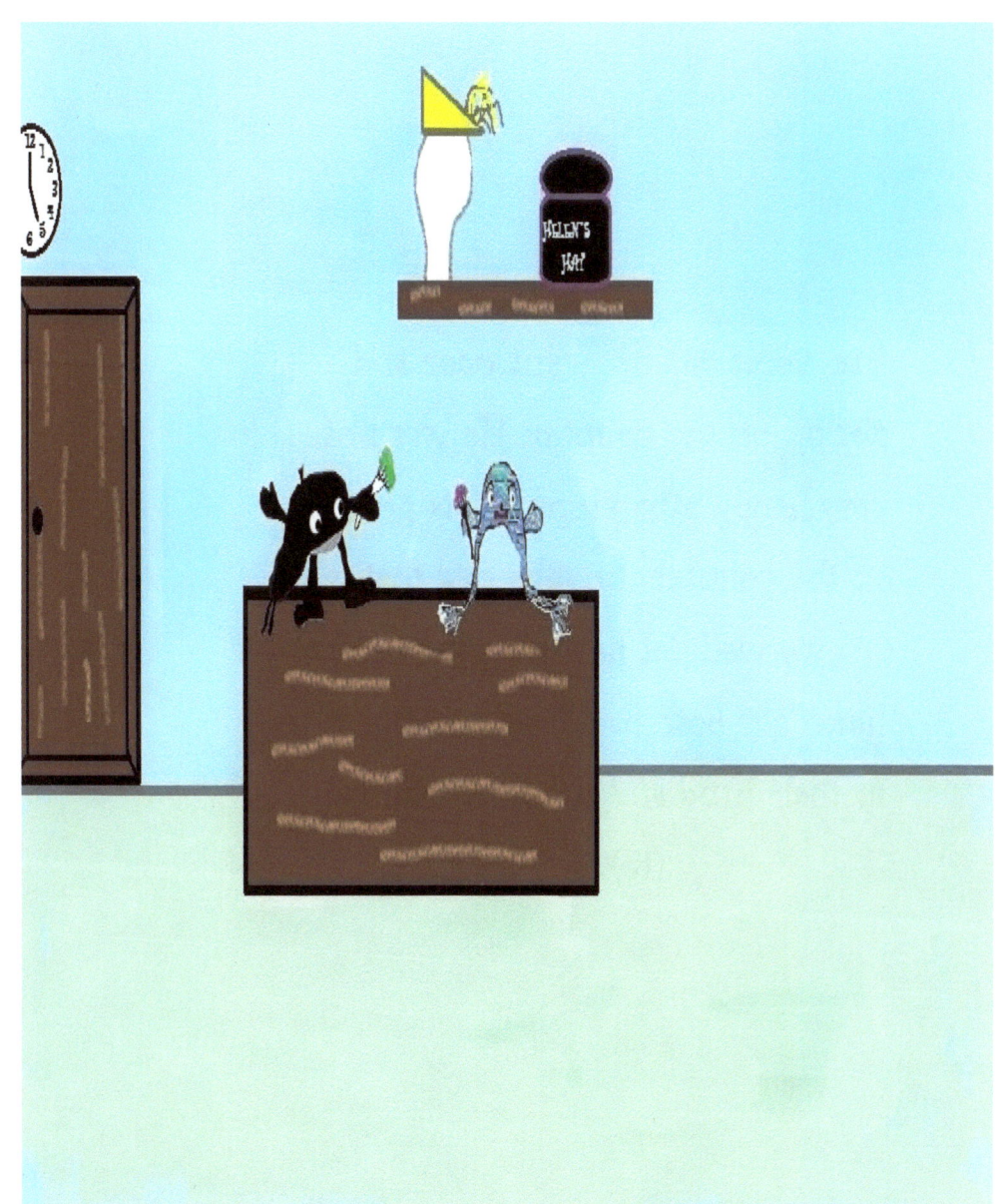

Mr. Beret got up, went over and got up on the counter. He was not very happy Miss Floppy Hats got up on the counter too. She said that is OK we well get her later and paint her. They both had their paint brushes in their hand and started laughing.

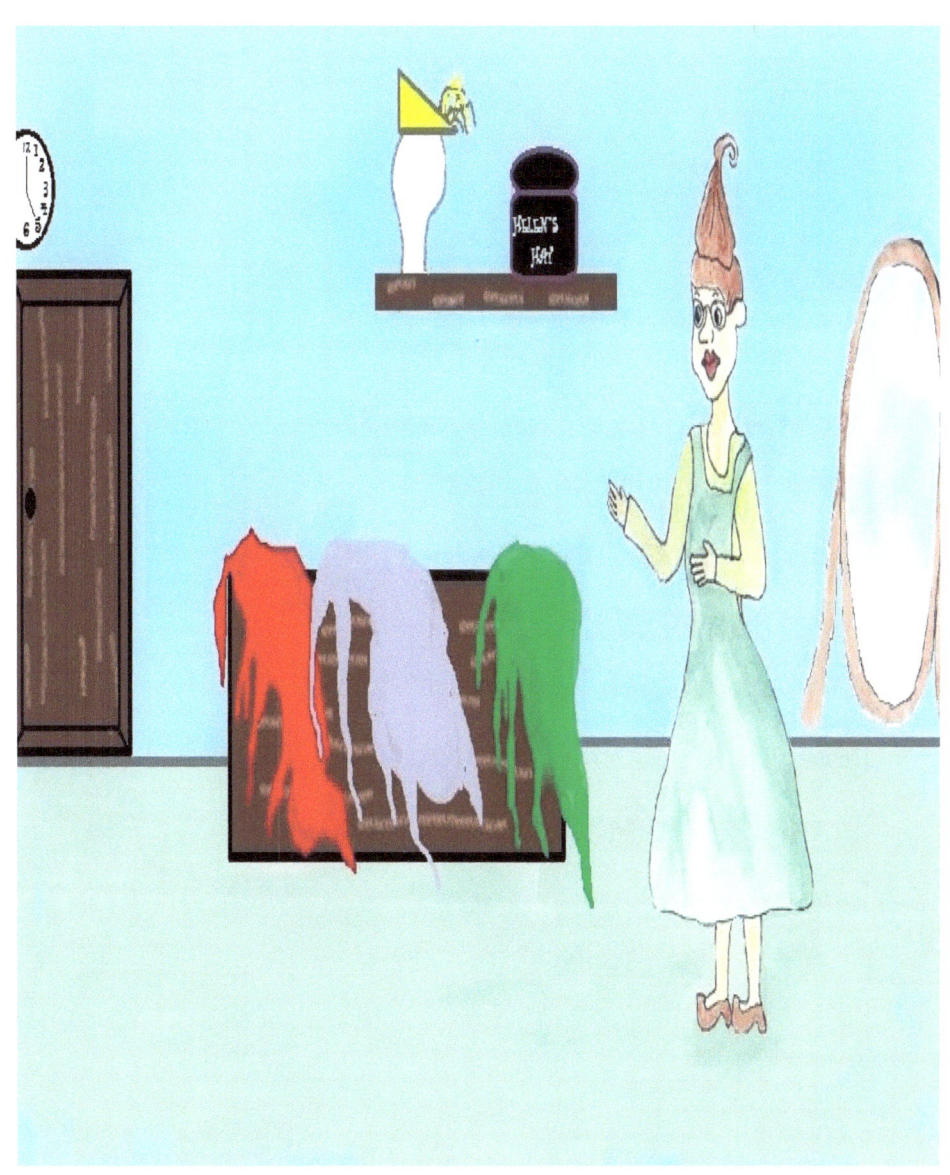

It was early Helen's had a new idea
For a Hat, she came in early.
She did that at times she looks at
the counter and there was paint all
over the counter Helen shocks, her
head and went smack, smack. She
thought to herself how does this
keep happen

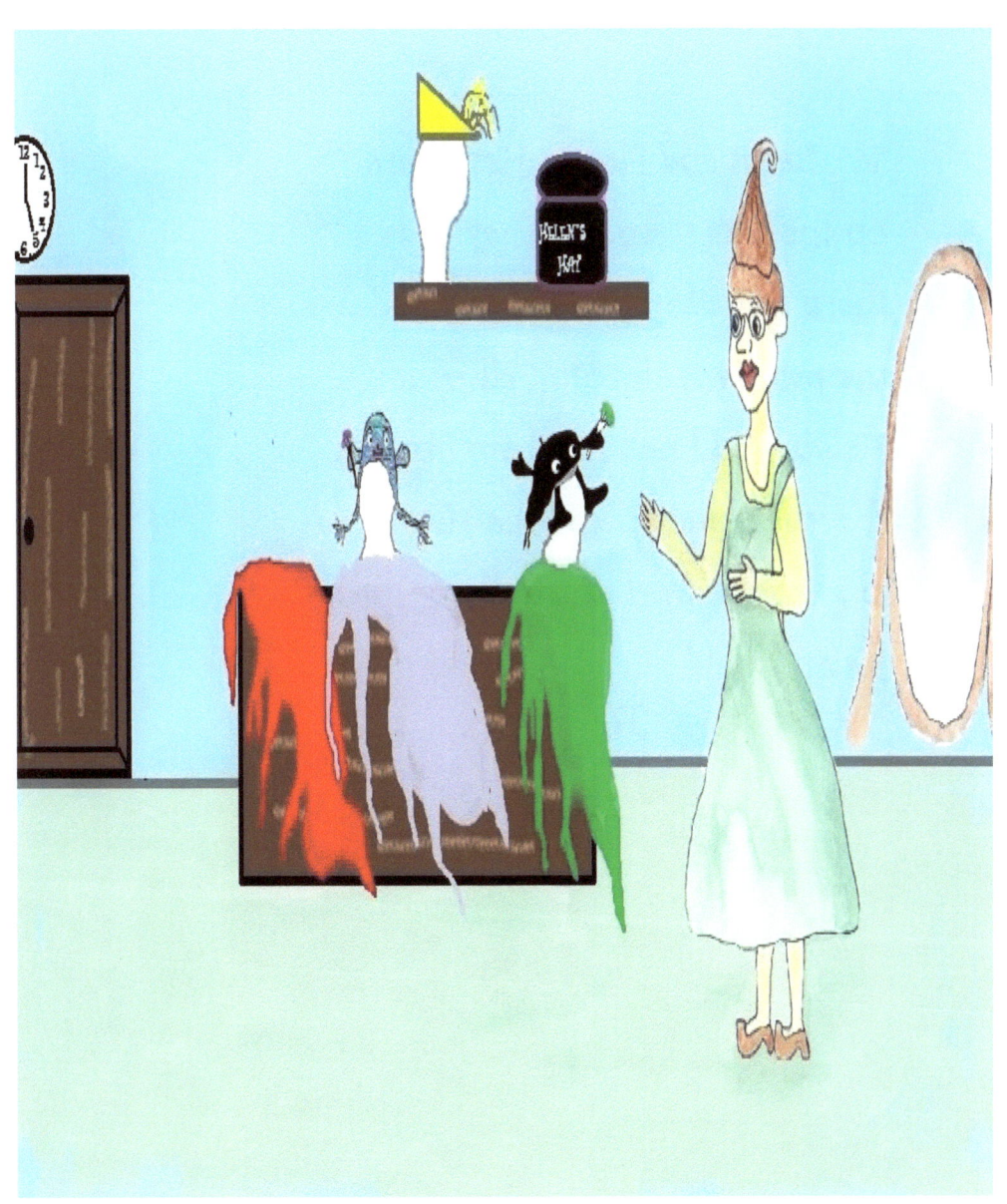

Mr. Beret and Floppy Hats were
on the hats stranded. They had
there paint brushed in hand and
the paint was dripping all over
Helen could not see them because
she was a person and the Hats lived
in a fantasy world that was not like
Helen world

(17)

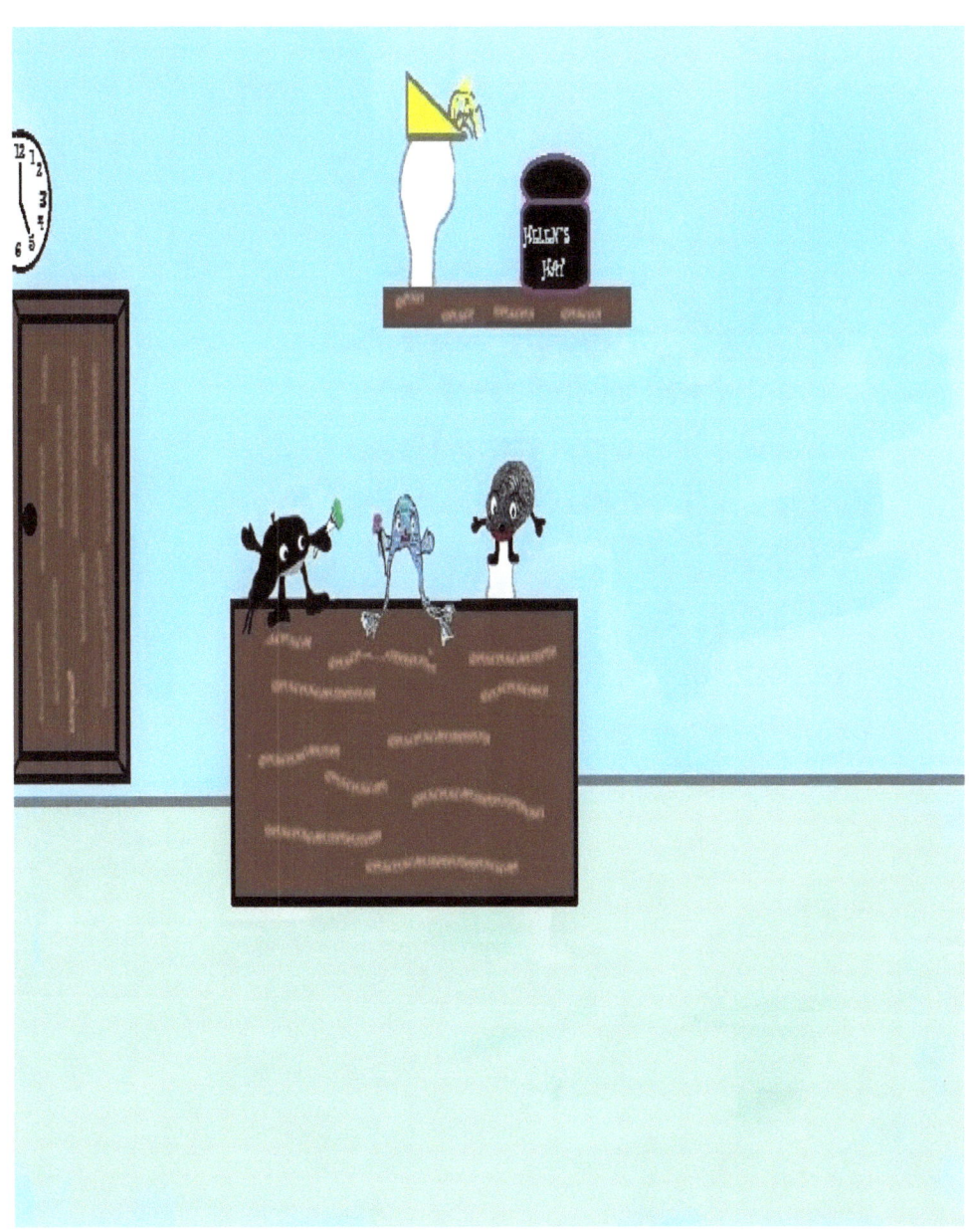

Helen had finished the new Hat it was the end of the day. She put the new Hat on the stand Helen closed up the shop for the night, Mr. Beret and Floppy ears were Looking at the new Hat on the counter top. All of a sudden a paint brush appears and
Mr. Beret said lets paint

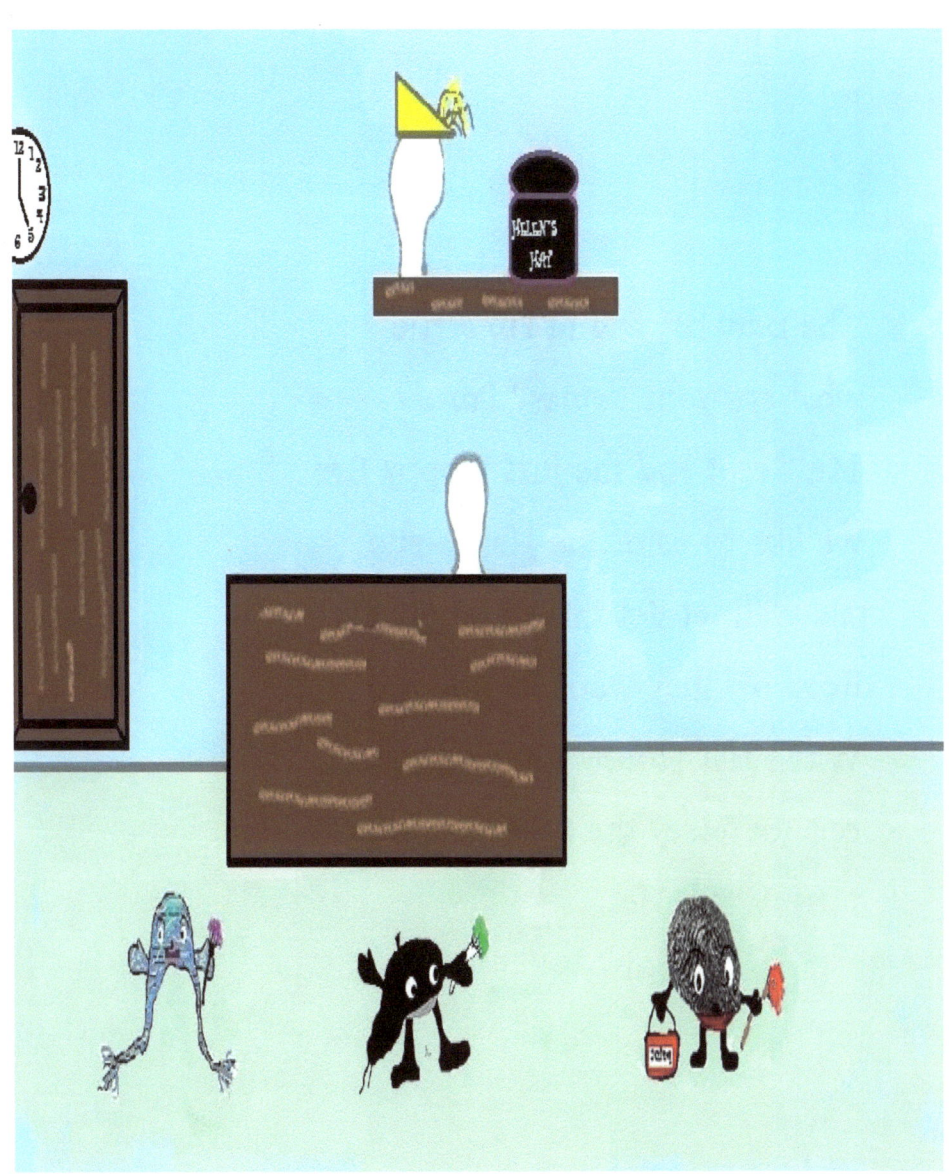

The new hat said hi I'm Artie what are your names? I'm Mr. Beret and she just Floppy Ear we like to paint the Hats Artie said well let get this show on the Road off they went to find the Witch Hat Floppy Ear said watch out for Mary the Cat she protects Miss. Witch Hat.

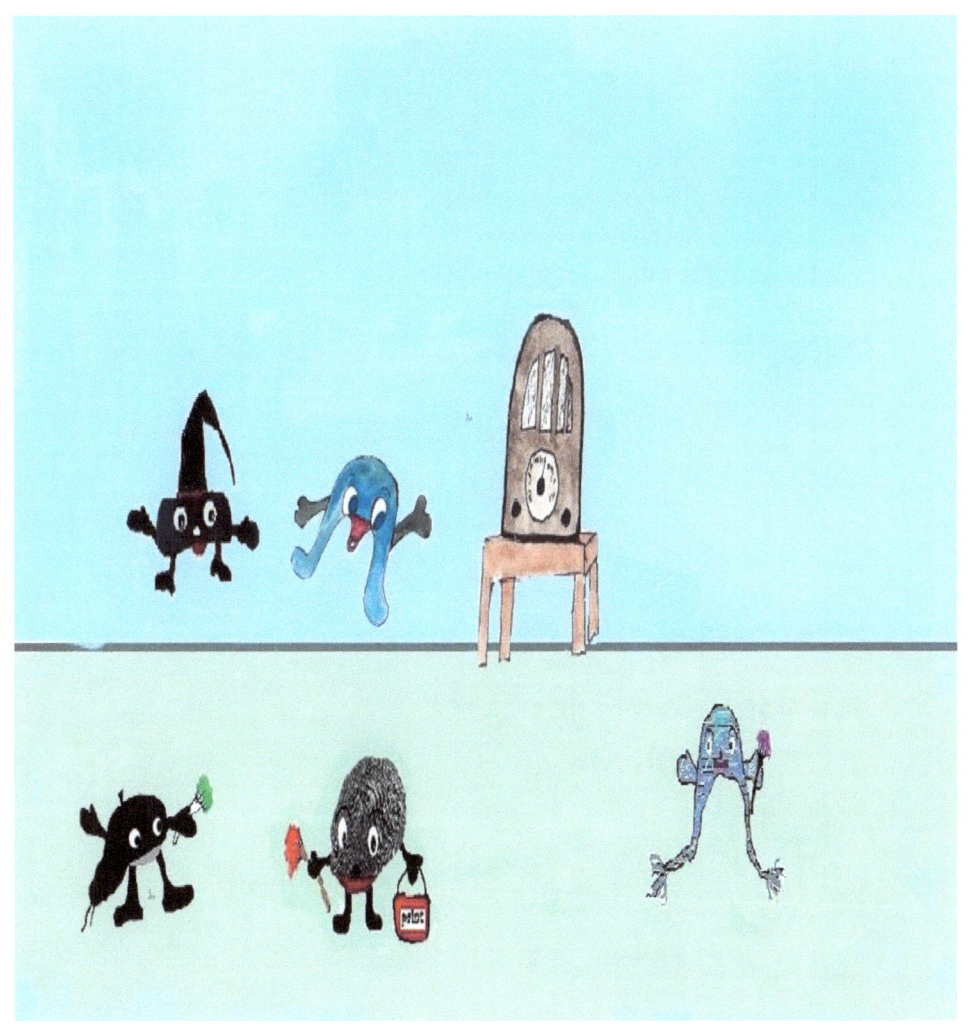

Miss. Witch was dance with
Miss. Cloche and they stop.
The new Hat was standing
with the other Art Hat, they
where smiling in a funny way
Miss. Cloche knew what was up
and stared to yell for Mary.

(20)

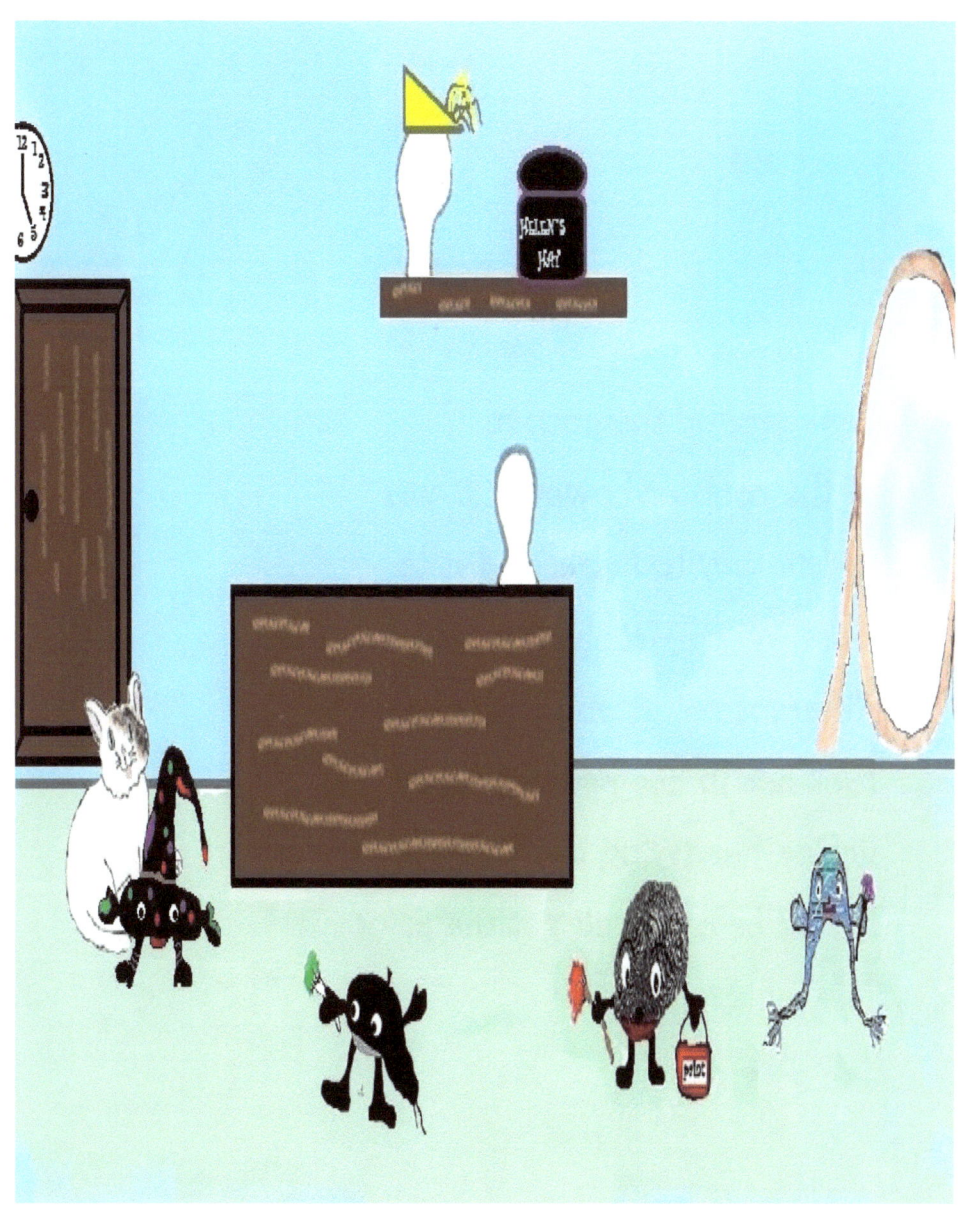

came around the corner
of the counter however, it was
to late they had already got to
Miss. Witch Hat she was all
different colors and crying. Mary
took her in her paws and was
licking her saying don't cry Misses,
it well be ok I well get the paint off.

THE END

The Next Book

www.ingramcontent.com/pod-product-compliance
Lightning Source LLC
Chambersburg PA
CBHW051058180526
45172CB00002B/692